HORSEPLAY

by

Leslie Enders Lee

FETHRA PRESS
NEW YORK

HORSEPLAY

Library of Congress Catalogue Card Number: 00-90107

ISBN 0-9678367-0-0

FETHRA PRESS
215 East 72nd Street
New York, New York
10021-4576

First Printing

Printed in Iceland by Oddi Printing

Berenson Design & Books, Ltd., New York
Sox Imaging, Inc., New York
Photo credits: Timothy Hill and Leslie Lee

Published on the occasion of the exhibition
HORSEPLAY: The Art of Leslie Enders Lee
100 Pearl Gallery, Hartford, Connecticut
June 8-August 19, 2000

For Dana and Shadow

CONTENTS

HORSES OF ANOTHER COLOR

HORSE TALK

PLATES

BIBLIOGRAPHY

ACKNOWLEDGMENTS

I set out to build a horse of iron.
At the forge it became much more...
A horse of a different color.

L. E. LEE, 2000

FOREWORD

In her sculpture and drawings series, "Horseplay," Leslie Lee explores the idea of the horse as subject, and she does this with characteristic elegance and wit. These thirty-odd works are spare and minimalist, their smooth lines frugal, their eloquent shapes essential. Though they are visually minimalist, the pieces are charged with meaning and intention: each one conjures up a different horse or a different metaphorical notion of the horse.

Lee, who likes working in series, has devised a basic form for this one: an austere and semiabstract head. This is replicated in different metals, each one using an identical template, cut and folded into place like metal origami. Lee varies the metals, the patinas, the details, and sometimes the medium itself, to produce this generous array of equine subjects. Telling details reveal each work's individuality. Lampos, one of the team that pulls the chariot of the Sun, according to Greek myth, is made of hammered brass, the brilliant shimmering surface resplendent with the notion of the sun's blinding image. The War Horse, of dark and sombre iron, wears overlapping layers of armor nailed

neatly and tinily in place, sternly declaring his martial invincibility. The Trojan Horse, of smooth, glowing wood, has surfaces so sleek and polished that it invites your hand to stroke it and render up its secret.

For her subjects, Lee wanders freely throughout the world and its cultures, observing and recording some of the ways the horse has entered into our lives. She ranges through time and space, from Xanthos, the talking horse from *The Iliad*, to Mr. Ed, the talking horse of television. She portrays specific legendary horses like Pegasus, and specific real-life horses like Phar Lap, the Australian racehorse. There are types of horses—the Quarter Horse and the Hobby Horse—and there are the horses of metaphor and wordplay. The Horse of a Different Color is here, and the Gift Horse, as well as Horseplay himself—a playful head, whose pricked and pointed ears are set in quizzical motion by the swing of an interior pendulum, like a child's toy.

Lee has been working with metal for ten years, and in "Horseplay" she reveals her formidable strengths in this medium. Her handling of clean, simple forms is skillful and assured, her sense of scale and proportion acute and instinctive. She shows a deep and subtle understanding of the fundamental sensibility of metal, its possibilities and its vocabulary. The facture,

too, the artisanship of these pieces, is remarkable. Lee addresses herself exquisitely to detail, and every seam, every juncture, every curve and surface displays this perfection of presentation. These, and all Lee's works, shimmer like Lampos with the artist's curiosity, inventiveness and responsiveness to the world.

Roxana Robinson
January 2000

THE HORSES

XANTHOS

Poseidon, the Greek god of horses, gave to Peleus as a wedding gift the immortal horses Xanthos and Balios. Peleus' son Achilles inherited this pair, and Xanthos became his lead chariot horse.

In a portentous moment in Homer's *Iliad*, Achilles is preparing his arms and chariot for the battle in which he will avenge the death of Patroclus, when Xanthos abruptly speaks with the voice given to him by the goddess Hera.

'We shall still keep you safe for this time, o hard Achilleus.
And yet the day of your death is near, but it is not we
who are to blame, but a great god and powerful Destiny...'

When he had spoken so, the Furies stopped the voice in him,
but deeply disturbed, Achilleus of the swift feet answered him:
'Xanthos, why do you prophesy my death?...'

This passage is, perhaps, the source of the expression *straight from the horse's mouth.*

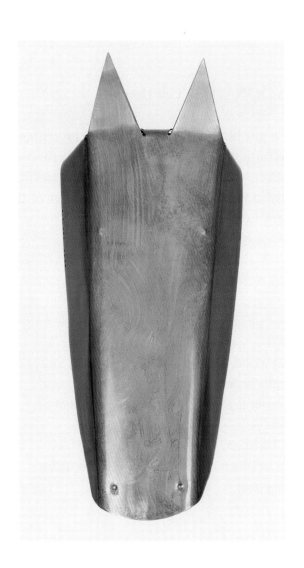

EQUUS DONATUS ("Gift Horse")

To look a gift horse in the mouth is to be critical
of something which has been received at no cost.
This notion stems from the practice of determining
the age of a horse by counting the number of teeth
and checking their condition.

St. Jerome, *Commentary on the Epistle to the Ephesians:
Prologue* (c. 400)
Noli equi dentes inspicere donati.
[Don't look carefully at the teeth of a given horse.]

John Heywood, *Proverbs and Epigrams* (1562)
Where gyftis be geven freely, est west north or south,
No man ought to looke a geven hors in the mouth.

Charles Dickens, *Great Expectations* (1861)
*"...we are looking into our gift horse's mouth with a
magnifying-glass."*

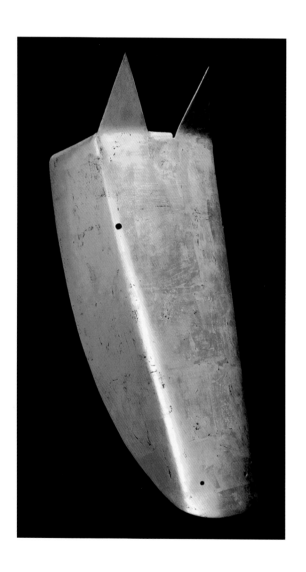

LADY HORSE-HEAD

In Chinese mythology the breeding of silkworms is
protected by Lady Horse-head about whom there is a
peculiar legend. Her father's kidnapping by pirates so
distressed her that she was unable to eat. Seeing her
daughter in despair, her mother promised that her
daughter would marry whoever could bring her
father back. The spoken vow was heard by the young
mistress' horse who went off in search of the missing
man, found him, and carried him home on his back.
When the horse demanded his reward, the father
became enraged, killed the animal, and hung its skin
to dry in the sun. A few days later, as the girl passed
by, the skin leaped upon her and carried her off.
But the August Personage of Jade—the greatest of
the Chinese gods and creator of human beings—
rescued the girl by changing her into a silkworm
and took her up to Heaven, where she became
Lady Horse-head.

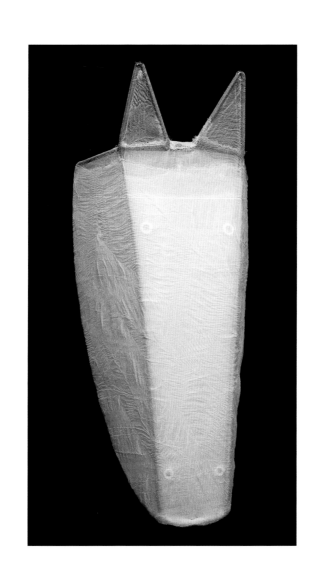

WAR HORSE

A heavy horse used in warfare; a charger (1653).

Famous War Horses in History

Bucephalus	Famous charger of Alexander the Great.
Ching Chui	One of the six war horses of the Chinese Emporor T'ai Tsung (7th century).
Cincinnati	Black charger of General Ulysses S. Grant during the Civil War.
Comanche	Cavalry horse; only survivor of Lieutenant Colonel George A. Custer's "Last Stand" in 1876.
Copenhagen	Carried the Duke of Wellington to victory in the Battle of Waterloo in 1815.
Marengo	White stallion which Napoleon rode in his defeat at Waterloo.
Nelson	General George Washington's charger, present at Valley Forge and Yorktown; remained with the President at Mount Vernon.
Reckless	A small Korean racing mare served as an ammunition carrier for a U.S. Marine platoon during the Korean War (1950-1951); made a sergeant and received a medal for bravery under fire.
Shiloh	William Sherman's horse, named after the Civil War Battle of Shiloh (1862).
Traveller	Gray gelding carried General Robert E. Lee during the Civil War.

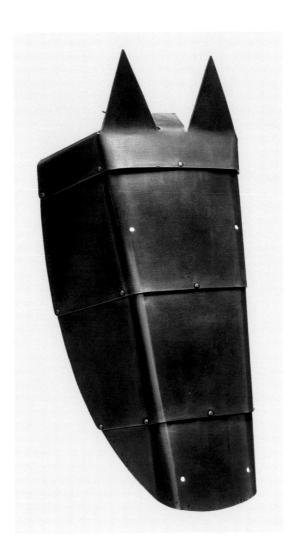

OCTOBER HORSE

In ancient Rome, horses selected as chargers for the
cavalry were dedicated to the god Mars at the end of
the harvest each year. On October 15, the close of the
Equiria (annual horse-races), a horse was sacrificed to
Mars who helped ward off disease which might attack
the crops. The horse's head was decorated with ears
of corn in thanks for the harvest. In this Roman
custom the horse embodied the corn-spirit.

The corn-spirit in the shape of a horse or mare
became part of the folklore of agrarian societies in
Western Europe for centuries thereafter. The spirit
was believed to hide in the last sheaf of harvested
corn. The thrasher was said to "beat the horse."
The first sheaf was called the "cross of the horse."
When the corn bent in the wind, one said "there
runs the horse." When a harvester grew weary,
he was said to have "the fatigue of the horse,"
and his customary noontime rest in the field
was called "seeing the horse."

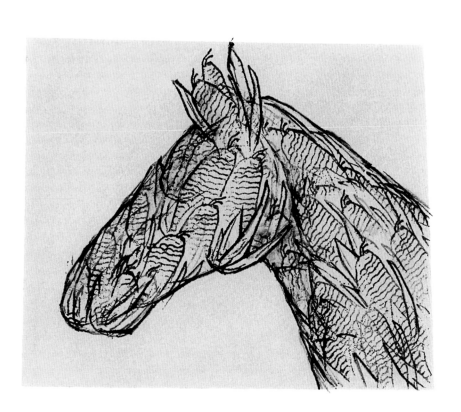

DARK HORSE

A little known, unexpectedly successful candidate;
in racing slang, a long shot.

This metaphoric expression may have originated in
Benjamin Disraeli's novel, *The Young Duke* (1831).

> *The first favourite was never heard of, the second
> favourite was never seen after the distance post,
> all the ten-to-oners were in the rear, and a 'dark'
> horse which had never been thought of, and which
> the careless St. James had never even observed in
> the list, rushed past the grandstand in sweeping
> triumph.*

Shortly thereafter, the term was used for political
candidates, the first of whom was James K. Polk.
This Presidential contestant in 1844 won the election,
although he was not nominated until the eighth
Democratic ballot.

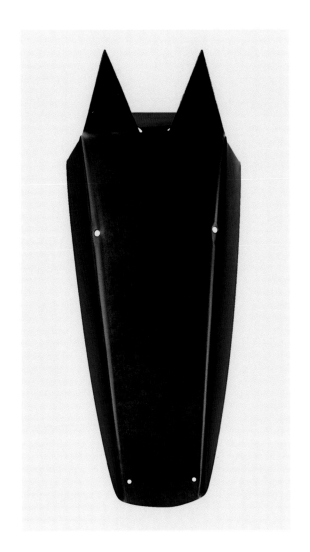

PHAR LAP ("Big Red")

In a career spanning only four racing seasons, Phar
Lap became Australia's most celebrated racehorse.
This champion had an unbeatable record of thirty-
seven wins and five places out of fifty-one starts.
In 1930 he won the Melbourne Cup, one of the
world's most challenging races. Thereafter, racing
rules were changed, with penalties added to curb
Phar Lap's winning. But neither injury nor adversity
could stop him as he triumphed from Australia to
America to Mexico. Americans called him the
"Wonder Horse." Alas, this gentle chestnut horse
died mysteriously at the age of five in Menlo Park,
California on April 5, 1932.

Phar Lap's stuffed hide is displayed in the Museum
of Victoria, Melbourne; his skeleton rests in New
Zealand (his birthplace); his large heart, in the
National Museum, Canberra.

> *A horse with a nation's soul upon his back—*
> *Australia's Ark of the Covenant, set*
> *Before the people, perfect, loved like God...*
>
> Peter Porter, *Phar Lap*
> *in the Melbourne Museum*

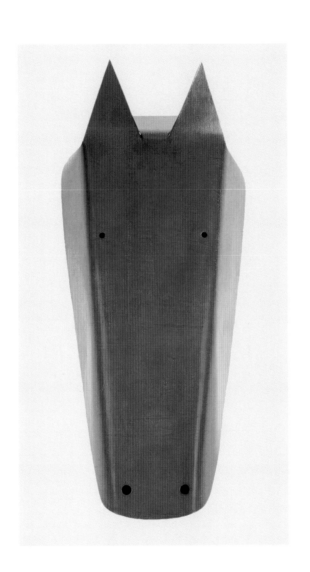

QUARTER HORSE

The Quarter Horse is the oldest all-American breed
of horse. Descending from the thoroughbred stallion
Janus, it was imported from England in 1756. First
known as a racing breed from the quarter-of-a-mile path
over which it was raced by the early Virginia settlers,
this horse became the most recognized short-distance
racer. When thoroughbreds and longer distance racing
were introduced into the United States, the popularity of
the quarter horse declined. However, with its desirable
qualities of speed, agility, and balance, it continued to be
bred as a ranch horse or cow pony. There is a renewed
interest in the quarter horse for sport.

"Ain't you never heard what Peter done?
Run the quarter-mile in twenty-one
And he run it backwards in twenty flat;
Why, stranger, where have you been at?"
"What else could he do,
This Peter McCue?"
"He could gallop the range with tireless legs,
He could build a fire and scramble the eggs;
Though he never learned to subtract or divide,
He was mighty good when he multiplied..."

J. A. Estes, in *The Blood Horse*
January, 15, 1944

IRON HORSE

A railway locomotive (1825); a bicycle or tricycle (1875).

In 1830, Peter Cooper designed and constructed the first steam locomotive in America, the *Tom Thumb*. Wanting to convince the Baltimore and Ohio Railroad officials that a locomotive was superior to a horse for pulling a train, Mr. Cooper staged a race between his locomotive and a horse. Alas, after an engine belt slipped on the *Tom Thumb*, the race was won by the horse. This defeat was only a minor setback for the "iron horse."

I LIKE TO SEE IT LAP THE MILES

I like to see it lap the miles
And lick the valleys up.
And stop to feed itself at tanks;
And then, prodigious, step

Around a pile of mountains,
And, supercilious, peer
In shanties by the sides of roads;
And then a quarry pare

To fit its sides, and crawl between,
Complaining all the while
In horrid, hooting stanza;
Then chase itself down hill

And neigh like Boanerges;
Then, punctual as a star,
Stop—docile and omnipotent—
At its own stable door.

Emily Dickinson

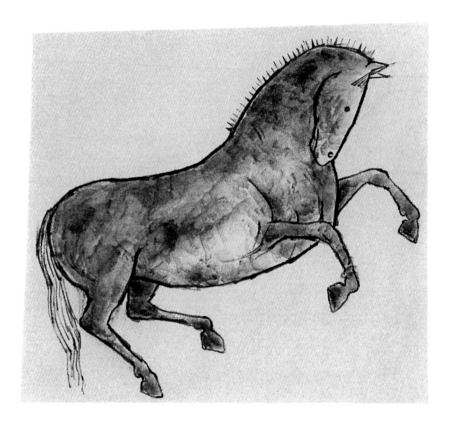

PICTURE HORSES

Beginning in the 16th century, horses were used in Japanese Shinto shrines in religious practices and ceremonial rites to bring about rainfall and sun. In large shrines the presence of fine living horses was obligatory—one dark horse to cause rain to fall, a light dappled one to bring back the sun.

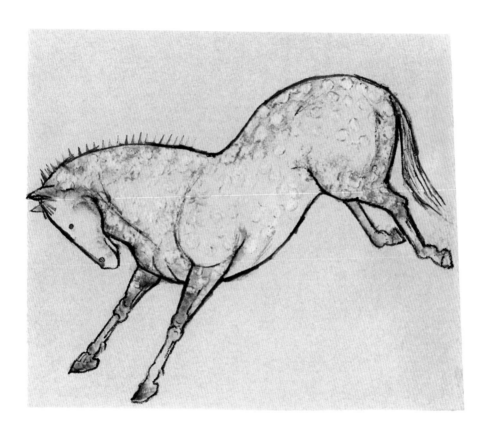

As maintaining suitable living conditions for these
horses was understandably difficult, certain shrines
substituted the live animals with painted images on
wooden panels (ema). The archetypal pairing in these
votive paintings is a rearing dark horse on the left and
a bucking, light, dappled horse on the right.

WORKHORSE

A horse used chiefly for labor; a draft horse.

A markedly useful or durable vehicle, craft, or machine.

A diligent or hardworking person.

Workhorse first appeared in 1543.
Work like a horse is an 18th century expression.

Here the workhorse is the iron template for the three-dimensional horse heads featured throughout this book. The words stamped in iron are the actual directions for the construction of each piece.

1. COLD BEND SIDES HALF WAY
2. PUSH UP EARS
3. DOME BROW
4. PUSH SIDES BACK ALL THE WAY
5. PUNCH EYES
6. PUNCH NOSTRILS
7. BEND SIDE TABS HOT
8. SQUEEZE AT MIGRAINE POINTS
9. FOLD MANE

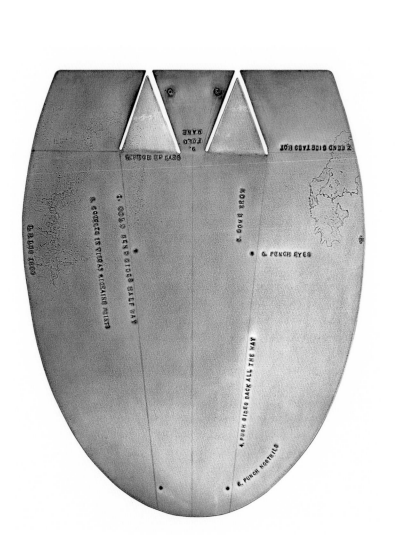

LETTERED HORSE

A well-trained or educated horse.

A horse schooled in classical dressage can execute a complex series of maneuvers in response to barely perceptible movements of its rider's hands, legs, and weight. In dressage tests, individual letters of the alphabet are placed in a standard order around the arena, and the rider and horse are asked to follow a specific sequence of steps and movements.

<div align="center">

K V E S H

A D L X I G C

F P B R M

</div>

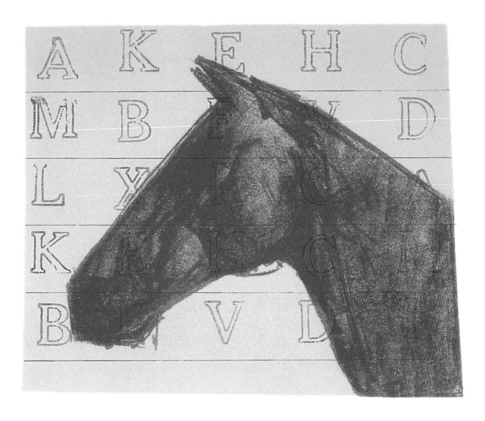

SILVER

The Lone Ranger's horse.

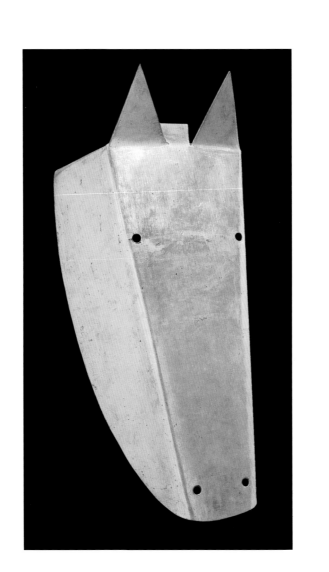

MR. ED (The Talking Horse)

A television series (1961-1966) based on stories by Walter Brooks, published in *Liberty Magazine* starting in 1937.

A palomino called Bamboo Harvester and renamed Mr. Ed was taught to "speak" by Lester Hilton, one of Hollywood's best animal trainers. To this day there is speculation about the method used to set Mr. Ed's mouth in motion. Alan Young, who played Wilbur Post in the television series, reportedly claims that peanut butter placed in Mr. Ed's mouth did the trick.

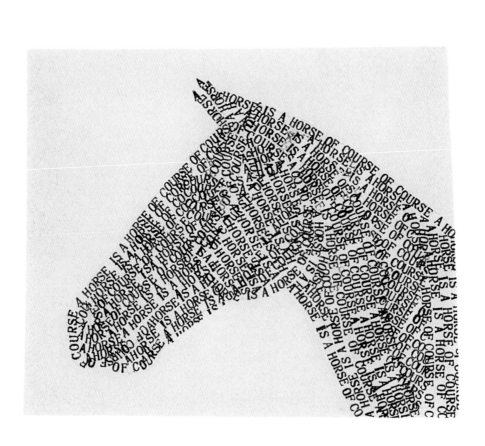

EPONA

A Celtic fertility goddess and protector of horses.

The ancient Celts held horses in high esteem and granted them a rank in their mythology. Among Celtic animals, the horse was afforded special privileges and was the only animal whose meat was not consumed. Epona, the "Divine Horse" or "Horse Goddess," was one of the few Celtic goddesses to enjoy a widespread following. She was adopted by the Roman army cavalry as a protector of horses, and her power spread throughout Europe. Her effigy was placed in stables everywhere.

Epona is often represented as a white mare. The White Horse at Uffington, a 370-foot-long figure of a horse cut into the chalk hillside during the 1st century B.C., may be a representation of Epona.

Children in Britain believe it is lucky to see a white horse—a symbol of life.

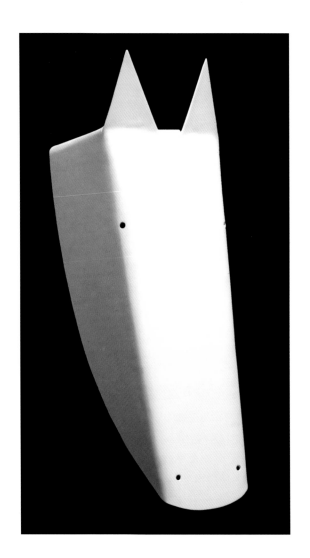

LAMPOS

In classical mythology, Helios, the Sun, drove a golden chariot powered by eight dazzling winged-horses:

Actaeon ("effulgence)
Aethon ("fiery red")
Amethes ("no loiterer")
Bronte ("thunderer")
Erythroes ("red producer")
Lampos ("bright one")
Phlegon ("burning one")
Purocis ("fiery hot")

Legend tells us that the Titans drowned their nephew Helios in the ocean and then raised him to the sky where he became the radiant sun. Every morning Helios emerged in the east and climbed the vault of heaven with his horse-drawn chariot to give light. It is said that in the evening his horses descended to the ocean, where they rested at the western end of the earth on the Islands of the Blessed. Here they grazed on a magic herb.

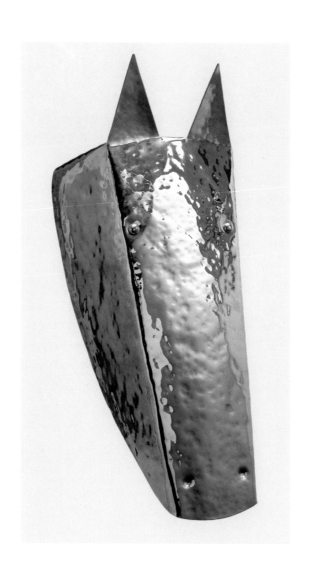

PEGASUS

An immortal winged horse or "sky-horse" in
Greek mythology; one of the famous Wind Horses.

Pegasus arose from the blood shed when Perseus
struck off the snake-haired head of the Gorgon
Medusa. Bellerophon, a mortal, tamed the winged
horse Pegasus and rode him on many adventures.
Bellerophon's attempt to ride Pegasus up to Mount
Olympus, the heavenly home of the gods, angered
Zeus, king of the gods. Zeus sent a gadfly to sting
Pegasus, which, in turn, caused the horse to buck
and throw Bellerophon to Earth. Alone, Pegasus
reached Olympus, where he remained and carried
Zeus' bolts of lightning and thunder.

On Mount Helicon numerous springs gushed forth
where the hooves of Pegasus struck the ground.
Two of these springs, Aganippe and Hippocrene, had
the virtue of inspiring those who drank their water.
Thus, Pegasus came to symbolize poetic inspiration.

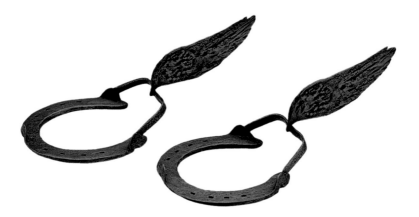

SEA HORSE

A small fish having a head resembling that of a tiny horse.

A large white crested wave.

In classical mythology, Zeus and his brothers drew lots for their share of the universe. Heaven was won by Zeus, the sea by Poseidon, and the underworld by Hades. With a blow of his trident, Poseidon created the horse from rock and gave the first one to man. As the horse deity, Poseidon could be seen driving his chariot pulled by two sea horses (half horse/half fish). Poseidon often assumed the form of a bird, ram, bull, horse, or dolphin. The ancient Greeks and Romans offered horses and bulls, symbols of fertility, in sacrifice to the sea. Thus, on occasion, a white horse, considered to be of enormous value in ancient Greece, was drowned in the sea.

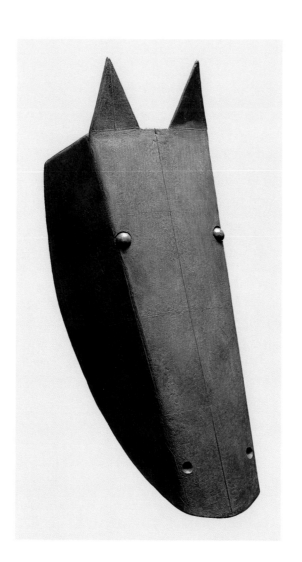

SLEIPNIR

The gray horse of Odin, chief god in Norse mythology.

Legend tells us that Loki, a "shape-changer" and "master of duplicity," carried out pranks endangering the gods and then made heroic rescues.

In one such tale, a giant was building a wondrous stallion, Svafilfari. The giant had been promised that the goddess Freyja would marry him if he could complete the horse in the course of a single winter. The sun and the moon were added as extra payment. Loki, fearing the giant would succeed, turned himself into a mare and lured away the stallion. The mating resulted in a foal with eight legs enabling him to travel on land and sea. This creature, Sleipnir, became Odin's horse and carried him on his journeys to the underworld.

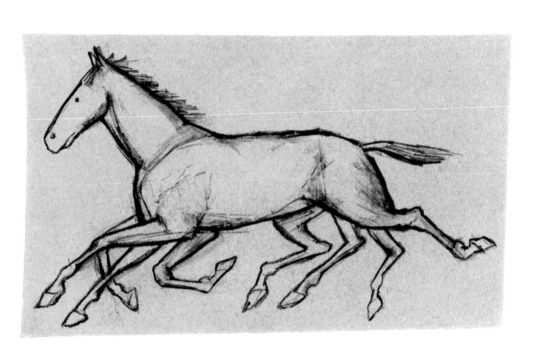

HOBBYHORSE

A toy consisting of a wooden horse's head attached to a stick, across which a child straddles (1589).

Hobby—archaic: a small horse, originally from Ireland.

A light wickerwork frame, draped with cloth, under which a dancer skips about and imitates the movements of a skittish or spirited horse.

Morris Dances, popular beginning in the 15th century in England, took place during the May games and festivals. The dancers often represented characters from *Robin Hood*, including the stock players of the "fool," "clown," and "hobby horse" or "dragon." A ladle was sometimes suspended from the horse's mouth for the purpose of collecting money from the spectators.

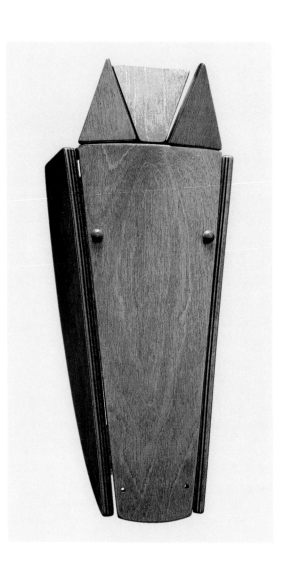

TROJAN HORSE

An attractive deception; a concealed danger.

Source of the proverb *"Beware the Greeks bearing gifts."*

The legend of the fall of Troy, which has an historical basis and probably took place around the 13th century B.C., inspired Virgil's great epic poem, *The Aeneid*.

The Greek army laid siege to Troy for nearly ten years, but could not conquer the city. Virgil recounts that the Greeks built a huge wooden horse and placed it outside the walls of Troy. Odysseus and his fellow warriors hid inside the horse, while the rest of the Greek army sailed away. The Trojans, unaware that the horse was packed full of Greek soldiers, thought it was a sacred offering of protection from the gods and dragged the horse into the city. That night the soldiers crept out, killed the guards, and set fire to Troy. Aeneas was among the few surviving Trojans.

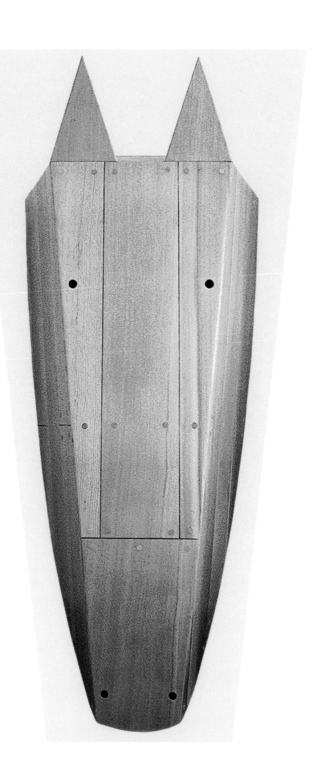

Broken in war, set back by fate, the leaders
Of the Greek host, as years went by, contrived
With Pallas' help, a horse as big as a mountain.
They wove its sides with planks of fir, pretending
This was an offering for their safe return,
At least, so rumor had it. But inside
They packed in secret, into the hollow sides
The fittest warriors...

Virgil

OLD WAR HORSE

The term originated in the 17th century for a
military charger that had been through many battles.

Until the 14th century the obligatory killing of the
war horse was part of the funeral rites of the war
lord, so that the horse could continue to serve its
master in an afterlife.

Term used for human veterans (1837), actors (1910),
politicians, and tough or determined women (1959).

Dependable, frequently performed attraction.
Popular musical production (1947).

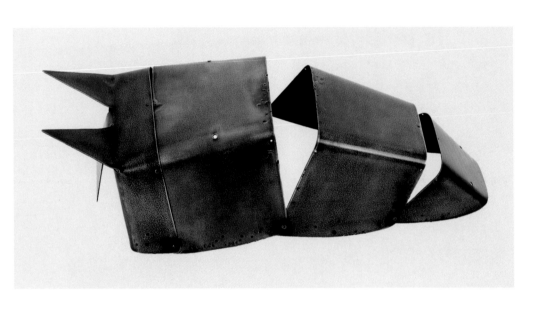

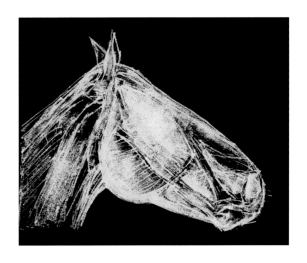

FOUR HORSES OF THE APOCALYPSE

In the Bible, Revelation:6, the Lamb broke four
of the seven seals from God's scroll. The first of the
broken seals revealed *a white horse, and its rider held a
bow.* From the second seal came *another horse, all red;
and he [his rider] was given a great sword.*

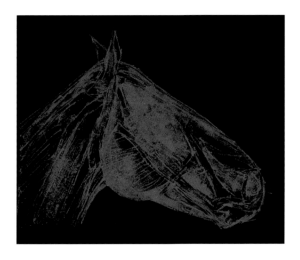

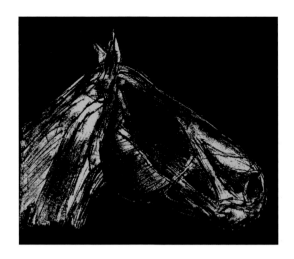

With the third seal there came *a black horse;*
and its rider held in his hand a pair of scales.
When the fourth seal was broken, there
appeared another horse, *sickly pale;*
and its rider's name was Death.

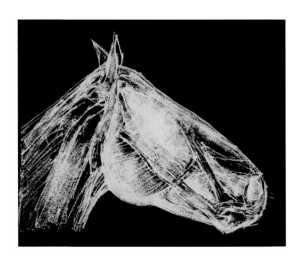

HORSES
OF
ANOTHER COLOR

HORSE OF A DIFFERENT COLOR

A different matter.

A horse of that color is the same matter.

In the 1939 magical film *The Wizard of Oz*, adapted from L. Frank Baum's first *Oz* book (1900), a carriage horse changes from white to an array of colors. When the carriage driver is queried by Dorothy about what kind of horse this is, he declares, "There's only one of him, and he's it. He's the Horse of a Different Color you've heard tell about!"
[MGM is reported to have used gelatin to dye the horse its various hues, and it is rumored that it was difficult to keep the horse from licking off the dye during the filming.]

In this movie, *the Horse of a Different Color* is a literal allusion to Shakespeare's figurative expression
a horse of that color. The latter phrase first appeared in Shakespeare's comedy of love, Twelfth Night (1600).

Toby:	*He shall think by the letters that thou*
	wilt drop, that they come from my niece,
	and that she's in love with him.
Maria:	*My purpose is indeed a horse of that color.*

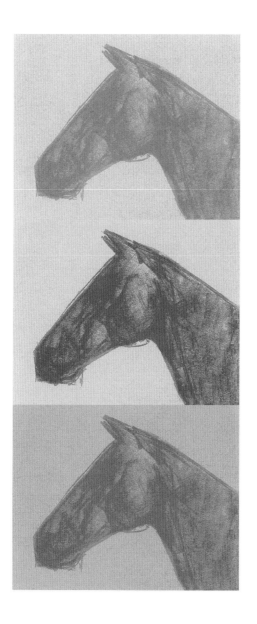

HORSE LATITUDES

A region of high pressure, calms, and light variable
winds, 30 degrees north and south of the Equator.
Sailing ships carrying horses to America and the
West Indies sometimes jettisoned their horse cargoes
when becalmed in these latitudes for shortage of
fresh water and to reduce the weight of the ship.
The origin of Horse Latitudes (1700s) may, in fact,
be the *Golfo de las Yeguas*, "Gulf of the Mares,"
the Spanish name for the waterway between Spain
and the Canary Islands.

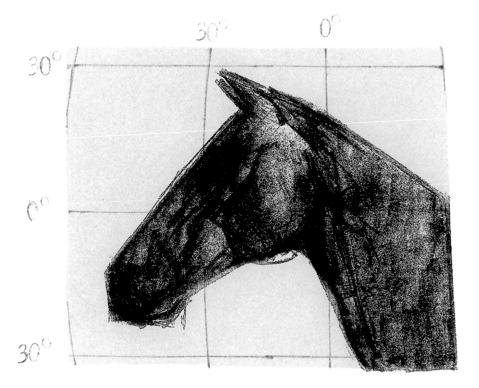

HORSE LATITUDES

When the still sea conspires an armor
And her sullen and aborted
Currents breed tiny monsters,
True sailing is dead
Awkward instant
And the first animal is jettisoned,
Legs furiously pumping
Their stiff green gallop,
And heads bob up
Poise
Delicate
Pause
Content
In mute nostril agony
Carefully refined
And sealed over.

The Doors

HORSEPLAY

Rough, boisterous play (1589).
Horse around : to engage in horseplay—to laugh,
push, or joke around (c. 1928).

This toy or "play" horse's hinged ears are set in
motion by the swing of the pendulum.

Certain positions of the ears may indicate a horse's
attitude. When a horse twitches its ears or lays
them back against the head, it is angry and may kick.
When it points its ears forward, it is curious about
something in front of it.

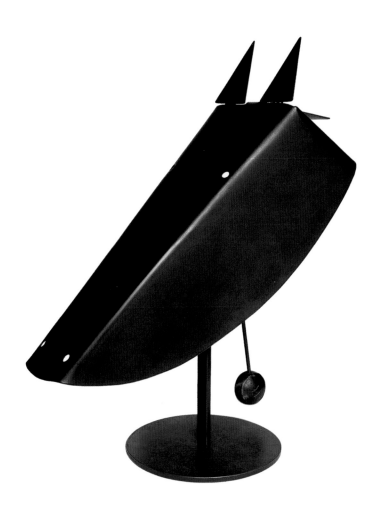

CRAZY HORSE

Tasunke Witko—in the Lakota language the name means "Holy, Mystical, or Inspired Horse."

Crazy Horse (c.1841-1877) was chief of the Oglala Sioux Indian tribe. He led the Sioux in the battle of the Little Bighorn, where Lieutenant Colonel George A. Custer and his command were wiped out.

He was known to his people as "our strange one" and was said to have unusual spiritual powers. He was called "Curly" until the age of fifteen when he received his grown-up name, Crazy Horse, by proving himself to be brave and selfless during a horse-raiding expedition. In celebration of Curly's bravery, his father, Crazy Horse, passed on his name to his warrior son in the same way that his ancestral fathers, also named Crazy Horse, had honored their sons. Crazy Horse's boyhood vision that he could never be hurt by enemy arrows or bullets protected him throughout his life.

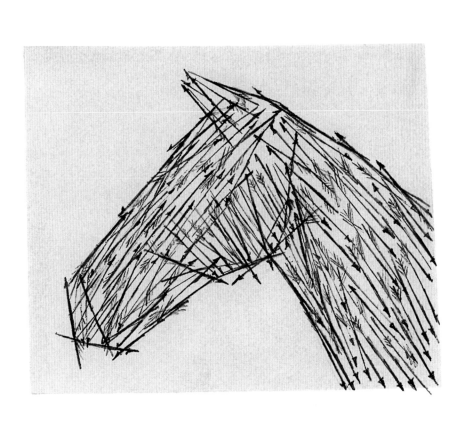

HORSE FEATHERS

Bunk or baloney; nonsense; rubbish.

Horsefeathers first appeared in Billy DeBeck's *Barney Google* cartoon (1928). In the episode of *Barney for President*, while "shooting the rapids in the perilous seas of politics," Barney exclaimed, "Don't worry boys. This is just a lotta horsefeathers to me."

Horse Feathers, a Marx Brothers comedy film (1932) starring Chico, Harpo, Groucho, and Zeppo, is an irreverent parody of academic life.

A carpentry term once used colloquially in New England and New York for feathering strips employed in the roofing and siding of houses.

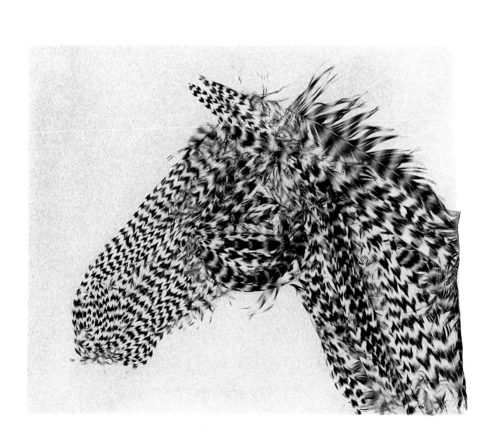

HORSE TALK

HORSEPOWER

horse around · horse-racing · horsey
horseback · horse latitudes · charley
horse · dark horse · horsepower- hour
horse gentian · horsemint · horse car
horsemeat · horse-whip · horsebrier
horse hockey · gift horse · horsepox
horsehead · horse pistol · horsebrush
horsemanure · horselaugh · horsebot
horse corn · hobbyhorse · high horse
horse balm · horse-faced · horsehair
horsefish · horseman · horse stinger
horse conch · clotheshorse · horsefly
horsecoper · horseshit · horse brass
horse sugar · horse parlor · seahorse
horse chestnut · pale horse · horsily
horsebridge · horsing · horseradish

horselike · horse-parsley · horse trail
horse's neck · horseless carriage · sky
horse · vaulting horse · pacing horse
horse wrangler · horse-fair · shaving
horse · horse furniture · horsepucky
horse trials · horseshoer · horsiness
horse-gear · white horses · pack horse
horsepond · heavy horse · light horse
horse-mill · sound horse · hard horse
horse artillery · brazen horse · show
horse · light horseman · death-horse
horseflesh · stalking horse · horse-pill
horse blanket · cart horse · horsebox
horse rack · harness horse · spotted
horse · horseshoe arch · coach horse
horse-stick · horse stall · crazy horse

horsefeathers · horseboy · sawhorse
horse-block · horse's ass · horse-post
horsemanship · horsefoot · horseboat
horse trader · horsetail · horseleech
horsecollar · horsehead nebula · war
horse · iron horse · horse mackerel
horserake · horseplay · horsewoman
horse talk · workhorse · horsebean
horse marine · horseshoe · racehorse
horseweed · dead horse · horse opera
horseshoe crab · horsecloth · trojan
horse · pommel horse · horse nettle
horse doctor · horse sense · cutting
horse · quarter horse · horsebreaker
horse-drawn · horseboot · dray horse
horse clam · draft horse · horsehide

horseshoes · celestial horse · horsian
horse milliner · cape horse · rocking
horse · horse ring · horseshoe magnet
horse-dragon · horse-packing · riding
horse · horse-mushroom · horse trailer
horse-country · wild horse · stamp of
horse · horse handicap · young horses
horse whisperer · headless horseman
horse park · magic horse · canal horse
horse show · gaited horse · stock horse
horse-archer · carriage horse · desert
horse · heavenly horse · winged horse
horse's mouth · trail horse · gun horse
horse-thieves · carousel horse · saddle
horse · cavalry horse · wooden horse
horse xing · troop horse · first horse

horse apple · horse-herd · stud horse
horse-nail · cold horse · police horse
horse-buss · horse-chaunter · shingle
horse · horseback opinion · horseless
horse piss · horse-jockey · thill horse
horse-course · october horse · sucker
horse · horse-necked jonquil · shales
horse · horse-charge · horse trumpet
horse-ladder · horse serum · trotting
horse · high school horse · horse-way
horse-house · horse-whipper · flying
horse · horse heaven · horse plunger
horse's mittens · horseman's weight
horse drover · horse fiddle · picture
horse · horse tail country · horse-hoe
horse piano · horse-hoof · horseward

horse-bread · horsetooth · horse salt
horse-high · horsehair worm · chalk
horse · horse-plum · horseshoe vetch
horse out · butter-footed horse · hick
horse · horse-bier · horse bill · long
horse · heavy horseman · horsehood
horse-master · horse-courser · shire
horse · horse-comb · horse up · side
horse · dead game horse · jerk-line
horse · night horse · horseman's bed
horse-lock · horse barn · horse's leg
horse mints · horse-hire · horse-belly
horse's meal · horse-keeper · blood
horse · willing horse · horse creek
horseness · horse away · horse tail
horse jog · horse dance · horse drama

horse it · horse's nightcap · unhorse
horse-kiss · one-horse team · lettered
horse · broken-winded horse · horser
horsed · horse-godmother · horseload
horse lawyer · horse-haired · horsen
horse lop · walking horse · one-man
horse · horseman's hammer · calico
horse · horse-shedding · divine horse
horse-faker · horsefully · horse over
horse-dung · horseshoe goose · crock
horse · horse-flesh wood · wild horse
horse-skin · horse goddess · roadster
horse · horse allowance · horse bird
horse-foot · wheel horse · horse calls
horsegate · stockhorse · devil's horse
horse race · liberty horse · to horse

PLATES

Dimensions are in inches; height precedes width precedes depth.

BIBLIOGRAPHY

Ammer, Christine. *The American Heritage Dictionary of Idioms.*
New York: Houghton Mifflin Company, 1997.

Beaconsfield, R. *The Young Duke.* New York: J. & J. Harper, 1831.

Brewer, Ebenezer Cobham. *Dictionary of Phrase & Fable.* 15th ed.,
London: Cassell Publishers Ltd., 1995.

Carter, Isabel Ray. *Phar Lap: the Story of the Big Horse* [rev. ed.]
Melbourne: Lansdowne Press, 1971.

Chevalier, Jean and Alain Gheerbrant. *The Penguin Dictionary of
Symbols.* Trans. John Buchanan-Brown. New York: Penguin Books,
1994.

Cirlot, J.E., *A Dictionary of Symbols.* New York: Philosophical Library,
Inc., 1962.

Collins Thesaurus. Glasgow: 1995.

Dickens, Charles, *Great Expectations.* 1861.

Edwards, Elwin Hartley. *The Encyclopedia of the Horse.*
London: Dorling Kindersley, 1994.

Encyclopedia of World Mythology. New York: Galahad Books, 1975.

Facts on File Encyclopedia of Word and Phrase Origins.
Robert Hendrickson, 1997.

Felson-Rubin, Nancy, "Pegasus." *World Book Encyclopedia*. 1991 ed.

Franklin, Ralph, ed. *The Poems of Emily Dickinson*.
Cambridge, Mass: The Belknap Press of Harvard University Press, 1998.

Frazer, James G. *The Golden Bough*. New York: Gramercy Books,1981.

Freedman, Russell. *The Life and Death of Crazy Horse*.
New York: Scholastic Inc., 1996.

Funk, Charles Earle. *Horsefeathers and other Curious Words*.
New York: Harper & Brothers, 1958.

Hallewell-Philipps. *Dictionary of Archaic and Provincial Words*.
New York: E. P. Dutton & Co., 1924 ed.

Hamilton, Edith. *Mythology*. Boston: Little Brown, 1942.

Heywood, John. *The Proverbs and Epigrams*. 1562.

Hickman, Money L. *Japan's Golden Age: Momoyama*.
New Haven: Yale University Press, 1996.

Homer. *The Iliad*. Trans. Richmond Lattimore.
Chicago: University of Chicago Press, 1964.

Jung, Carl G. *Man and His Symbols*. New York: Doubleday, 1964.

Mathews, Mitford M., ed. *A Dictionary of Americanisms on Historical Principles*. Chicago: University of Chicago Press, 1951.

Migne, Jacques-Paul. *Patrologia Latina.*

Moon, Beverly, ed. *An Encyclopedia of Archetypal Symbolism.*
Boston: Shambhala, 1997.

Moscati, Sabatino, Frey et al., eds. *The Celts.*
New York: Rizzoli, 1991.

New English Bible. New York: Oxford University Press, 1971.

New Larousse Encyclopedia of Mythology. 1968 ed.

Oxford English Dictionary. 1989 ed.

Partridge, Eric. *A Dictionary of Slang and Unconventional English.*
London: Routledge & Kegan Paul, 1984 ed.

Paul (Uncle P.J.), "Mr. Ed the Talking Horse Story."
1999 <Wysiwyg://36/http://nsccux.sccd.ctc.edu/unclepj/mr ed>.

"Phar Lap: Australia's Wonder Horse."
1999 <http://www.mov.vic.gov.au/pharlap/plbet.htm>.

Price, Steven D. and Bill Landsman, "Horse."
World Book Encyclopedia. 1991 ed.

Shakespeare, William. *Twelfth Night.* 1600.

Smith, William George and Janet E. Haseltine.
Oxford Dictionary of English Proverbs.
Oxford: Clarendon Press, 1952 ed.

Spears, Richard A. *NTC'S Dictionary of American Slang.* 1995 ed.

Stevenson, Burton. *Home Book of Proverbs, Maxims and Familiar Phrases.*
New York: The Macmillan Company, 1948.

Urdang, Lawrence. *Idioms and Phrases Index.*
Detroit: Gale Research Company, 1983.

Virgil. *The Aeneid.* Trans. Rolfe Humphries.
New York: Charles Scribner's Sons, 1951.

Walker, Brian. *Barney Google and Snuffy Smith.*
Wilton, Conn.: Comicana Books, 1994.

"The Wizard of Oz from 'A' to 'Z'."
2000 <http://www.geocities.com/Hollywood/Hills/6396/ozfromatoz.htm>.

In the summer of 1997, I began making horse heads
with the help of a blacksmith and fellow artist,
Jeffrey Havill, at a monastery in Bethlehem, Connecticut.

Here a lasting friendship was forged.

ACKNOWLEDGMENTS

At the starting gate:
David Finn, Caroline Goldsmith, Karen Hughes,
and Jeannette Watson.

Off and running:
Jan Abrams, Nancy Bardes,
Margaret Mathews-Berenson,
Adria Diel, Ed Dougherty, Alexandra Edmondson,
Amy, Anna, and Chris Farrell, Lori Gevalt,
Chuck Jaklebek, Anthony Krauss, Janice La Motta,
Karen Lee, Katherine Leiner, Caroline Lukaszewski,
Danielle Matusic, Louise Muller, and Kevin Rita.

Lapping the miles:
Richard Berenson, Bob Enders, Jr., Nick Lyons,
Richard Peterson, and David Spagnolo.

At the finish line:
my loving family—
Dwight, Derek, and Dana.